# Loving
# Aunt Ruth

with love,
Nancy

First published 2014 by

Verve Editions, Ltd.

99 Cliff Street | Burlington, Vermont 05401

www.verveeditions.com

To purchase copies:

Atlas Books

30 Amberwood Parkway | P.O. Box 388 | Ashland, OH 44805

800.247.6553

www.atlasbooks.com

Cataloging-in-Publication Data is available

ISBN 13-978-0-966-0352-4-7

Developed and produced by Verve Editions, Ltd. for Mentor Road Editions, LLC.

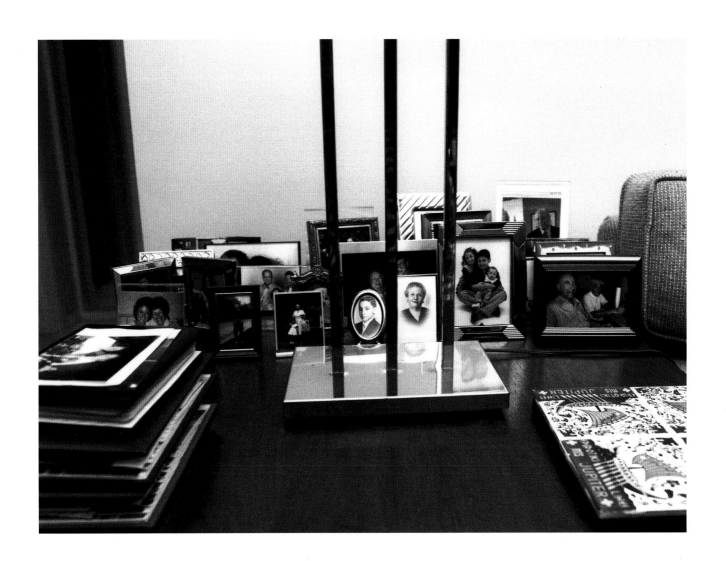

# Loving
# Aunt Ruth

## Recipes for a Life Well-Lived

Honey Lazar

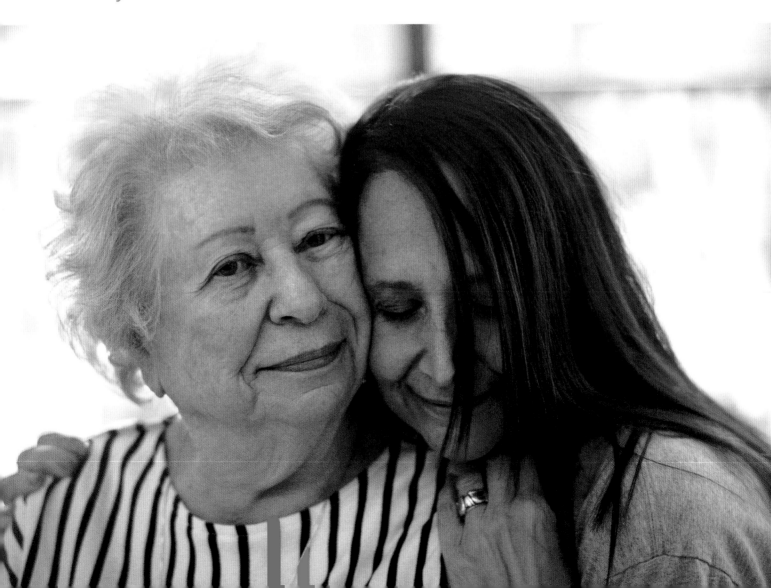

*With thanks to the wonderful people who make sure I have love in my life:*
*David, Matthew, Zachary, Rini, the Fonseca-Sabune Family, Mara, the Sidney-Bain Family,*
*Elizabeth, Tanya, Lauren, Debbie, Sara, Susanne, Cindy, Jill, Gai, Betsy, Mim, Tessa, Denis,*
*Garie, Keron, and Toby.*

*A special thanks to believers Gary, Maria, Gabrielle, Swannie, Leah, Rania, Aline,*
*Cynthia, Kristin, and Belleruth.*

*To my parents, Leah and Morrie, my sisters, Phyllis and Jane, and to my beloved Aunt Ruth,*
*I love you forever and ever.*

We live in a world made up more of story than stuff.
We are creatures of memory more than reminders, of love
more than likes. Being attentive to the needs of others might
not be the point of life, but it is the work of life.

"How Not to Be Alone", *The New York Times*
Jonathan Safran Foer

# FOREWORD

Nowadays many of us live at a distance from our parents, our siblings, our children, or best friends. We don't necessarily know our neighbors, and members of our professional and intellectual community may reside in another state or other country. Where is that extended family we once had? Where is that neighborhood café we used to go to in order to talk about life, philosophy, and art?

These days we log onto Facebook to see what our friends are doing and to share our latest woes or fortunes - and if that sounds shallow – it needn't be. It depends on how you choose your "friends". Honey Lazar and I have never met face-to-face except on Facebook. She, living in rural Ohio, and me in Upstate New York. We are both photographers who have had complex personal trajectories that we seek to express through our photographic work.

Honey's father was an artist who died when she was three-years-old. She has kept his memory close to her by loving his photographs, his paintings and becoming a visual artist herself.

More recently, her two older sisters died, leaving Honey feeling at times like an island unmoored in the ocean...

Honey's pain, loss, spirituality, generosity and love leaps through the synapses of cyberspace. Her book, *Loving Aunt Ruth*, touches us all and reflects our own need for unconditional love and that maternal embrace that Aunt Ruth offers so unstintingly, along with wise words, soul food and the inspiration for a wonderful suite of black and white photographs, a selection from the hundreds that Honey made over the years of this long term body of work.

Aunt Ruth says, "You must have a will to live. That will comes from loving people." And I would add, it also comes from being engaged in the work one loves.

Sylvia de Swaan

Sylvia de Swaan is a Romanian born photographer/visual artist who has lived and worked in Mexico, Europe and the United States.

In my daily life running a technology company that supports people who are aging in place, I spend endless hours contemplating the ins and outs of growing old – what it means for the elderly, and what it means for the scrum of people that evolve into a community of caregivers: their adult children and grandchildren, neighbors, doctors, pharmacists, homecare workers, etc. So much of what we hear about in this industry is the "burden" of caregiving. And make no mistake; it's an overwhelming responsibility. But what makes *Loving Aunt Ruth* so unusual is that it so poignantly and succinctly demonstrates that we invest in caregiving because the gift of having an older person in our lives is indisputable. In a world where plastic surgery and anti-aging gimmicks take center stage, *Loving Aunt Ruth* celebrates growing old and the opportunities that it opens up for all of us in this increasingly complex society.

Research shows that our cognitive abilities start to decline somewhere in our mid twenties. Yes, that's right – by the time we've finished college, we're already starting our downward slide. So why do most people's careers peak 30 years after that? The answer: experience matters. The unique perspective we develop from having actually lived through something is essential to our becoming mature and effective in assessing what life is throwing our way. Aunt Ruth's life experiences and unique perspective are what power the author, Honey Lazar, through the loss of most of her immediate family members – her father as a young child, her mother as an adult, and, during the process of writing the book, her two sisters.

It is through conversations with Aunt Ruth that Honey discovers a lens that makes life an exciting, innovative, profoundly fulfilling journey from start to finish despite road bumps along the way, and it is through her understanding of Aunt Ruth that she develops the resilience she needs to continue to find delight in the gift of life.

Lazar captures this life inspiration through vivid and emotive photography as well as deft and tender prose. Anyone who peruses this book will be imbued with Aunt Ruth's unique combination of calming and energizing reflections. Aunt Ruth has much to teach all of us.

Liddy Manson

Liddy is President of BeClose and an emerging voice on Aging in America. She has over 20 years of experience working with premier technology and information brands. Before joining BeClose, she served as CEO of DigitalSports, a web service providing detailed information and coverage of high school sports throughout the country. Prior to DigitalSports, she served as the Chief Operaing Officer of Freewebs Inc., an early-stage social publishing company. Previously, she spent nine years as the Vice President and General Manager of Commercial Products at Washington-post, Newsweek Interactive, the online subsidiary of The Washington Post Company. Liddy holds an MBA and Certificate in Public Management from Stanford University and a BA in Music from Yale University. She lives in Washington, D.C., with her husband, three children and a boisterous Irish setter.

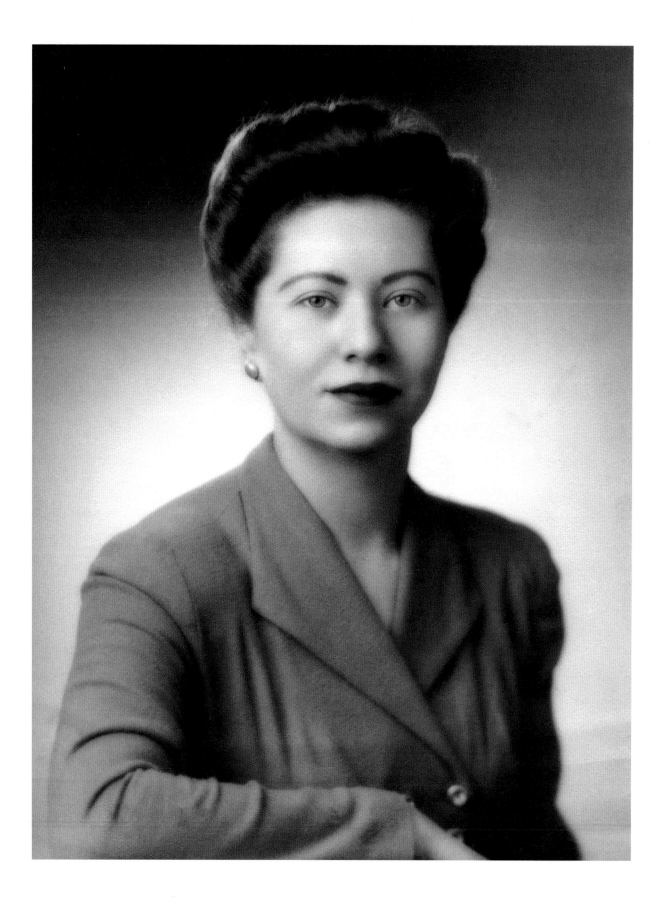

# Loving
# Aunt Ruth

## Recipes for a Life Well-Lived

Honey Lazar

*Loving Aunt Ruth* is the culmination of everything for which I have cared; family, story, respect, hardship, triumph, humor, and my work as a photographer. Like many Jewish women of the Greatest Generation, Aunt Ruth's most significant relationships took place within her family, but her reach extended to friends, her temple, and civic duty. She blended Jewish faith with American pride and a deep love of family. I didn't know very much about Aunt Ruth when I asked if I could photograph her for a book. I don't even know why I mentioned a book to her as a way of introducing my desire to photograph her, because my intention was simply for us to grow closer.

My parents built our house across the street from Aunt Ruth and her husband, my Uncle Bob. The sisters planned for a life of shared joy, which close proximity affords. Unfortunately, my father died when I was 3, on Aunt Ruth's birthday, and 3 years later, my mother's remarriage took us to a new city. I am lucky that my dad was a professional photographer whose prolific documentation of our family set an important precedent for me. Photography preserved memory. I learned everything I know about my dad from the pictures he took which made his loss more tolerable.

Aunt Ruth is the last of my family elders, so it was imperative that I follow my dad's example and photograph her while I could. I had a lot of ideas about how the photographing would go without ever imagining the surprise and importance of coming to understand the way Aunt Ruth lived through sharing conversations, asking questions, and spending time with and without my camera. I photographed Aunt Ruth culling recipes, putting on her make-up, doing the laundry, planning party, after party, after party, and celebrating countless Jewish holidays. I spent a day driving to every place she lived from birth to bride to the present day. "Which of your houses was your favorite?" I once asked Aunt Ruth. "That's easy. Mentor Road. I lived there for 40 years, and I still miss it, but I had to grow up and face that life would be easier in an apartment. I believe in planning for the future." Aunt Ruth and I created a rhythm of taking pictures followed by intimate conversations and receiving from her a gem of wisdom that I quickly recorded. Over time, the commentary created a flow of life lessons paired with images that told the story that I wanted and needed to understand as I approached sixty.

Her commitment to community included taking mechanics classes in order to be a staff car driver for the Army Air Corps, founding the Women's Auxiliary to the Ohio Bar Association in 1954, becoming President of her temple, and editor of her temple's cookbook. These achievements are surely noteworthy,

but the wisdom she gained from living her life determined to be generous, kind, and non-judgmental has taught me ways to transcend life's sorrows. Her recipes for a well-lived life, widely shared and deeply appreciated, enabled her to fill a room with 165 friends of all ages, religions, and ethnicities who came to help her celebrate her 90th birthday.

Aunt Ruth doesn't offer advice unless asked, and I asked. "How do you stay determined through so much loss?" She responded, "I accept that life isn't easy. I have my faith, but most of all, I have a will to live. That will comes from loving people." She inspires me to want to be a better sister, aunt, wife, mother, and friend, and she sets the example by sharing her stories, her food, her humor, and her experiences. "Appreciate everything," she once replied, when I asked her what she thought young people ought to know. A simple message often forgotten in the rush to *have* everything.

I took hundreds of photographs. I am a photographer who uses film, so I felt confident that the archival life of Aunt Ruth's images was secured, but the mental images of laughter and the lessons learned gave each frame a profound meaning that will surely influence me for the rest of my life. Aunt Ruth's life is rooted in love, a love that influences everything she does, from cooking a brisket to having a bench installed outside of her building just in case a weary resident might want to sit down.

My father left me the legacy of an understanding of photography's power, and it opened the door to my understanding of Aunt Ruth's philosophy of living life guided by loving and caring for people. Making pictures is the passion that led to the biggest surprise; the profound wisdom I learned from Aunt Ruth.

Lately, I have noticed that just before hanging up the phone with a niece, nephew, or any of her family or friends, Aunt Ruth says, "Don't forget to make sure that you always have love in your life. It is the greatest gift of all."

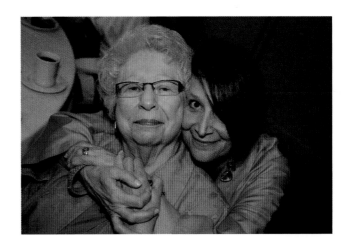

I love my wise and wonderful, beautiful and brave, and always loving Aunt Ruth.

Honey Lazar

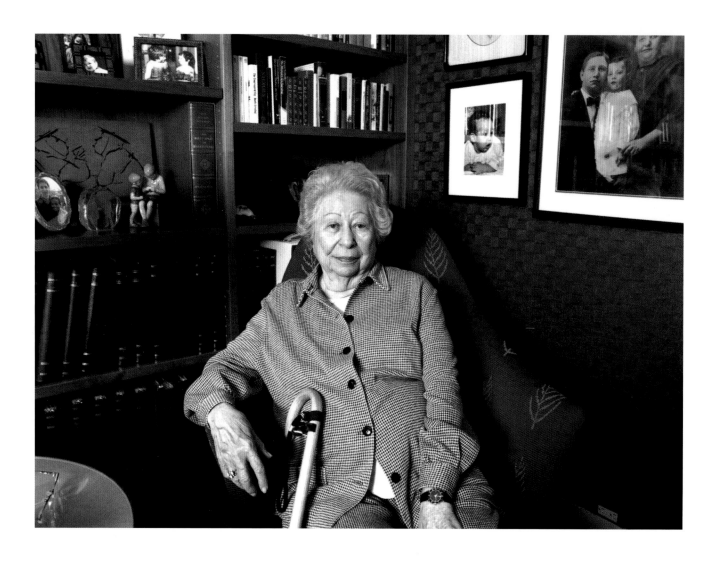

Aunt Ruth had a son, Kenny, and a daughter Suzie.
Kenny was funny, a fast runner, and a soldier during the
Vietnam years. He wrote a newspaper advice column when
he returned from serving and had dreams of working in film.
Suzie had red hair and freckles, and she and Aunt Ruth
were often seen in Mother-daughter dresses. She moved to
Alaska, worked on the pipeline, and became an accountant.
Suzie and Kenny are gone, and so was Aunt Ruth's husband,
my Uncle Bob. I worry about loss, so I asked Aunt Ruth how
she stayed determined in the context of her profound sorrow.
Her answer changed my life.

I accept that life isn't easy. I have my faith...but I have a will to live, and that will comes from loving people.

I have memory boxes for each of my two sons in our attic. I grew up with trunks of ephemera from my mother's life with my dad who died when I was three. I loved looking at the collection of memories.
I wondered how my children remember their childhood.

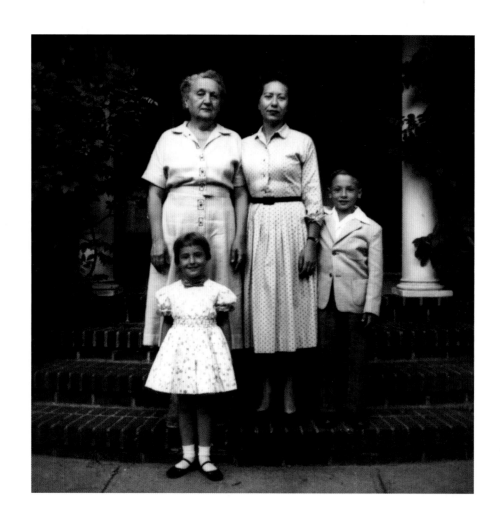

*I adopted my children. A boy and a girl. Our son was two when we adopted our daughter. In those days, adoption agencies gave new parents a book that I think was called, "The Chosen Child," and the agency workers told us to read it aloud as often as possible. We were instructed to tell our children that they were chosen from thousands of children and to repeat to them that they were the "chosen ones." I think this was a mistake.*

*I think it did our children an injustice. It didn't fulfill them, and it wasn't the truth. I wish they had known that my husband and I felt that we were the chosen ones.*

I made mistakes as a Mother. When you look into your heart for answers to child-rearing and act from goodness, your grown children will understand and forgive you.

I hope my children forgave me.

My mother was thirty-nine when she was widowed with three young daughters. I thought this was the reason she counseled my sisters and me to make certain we "kept money of our own." When I began photographing Aunt Ruth, I discovered that it was my grandmother who gave this advice to her daughters. Throughout Aunt Ruth's and my mother's lives, they kept a "little something" for themselves. They were careful and cautious women who learned from the Depression and from young widowhood that nothing is certain.

Remember that you are a person. You are not a Mrs. So and So. I kept money in my own name, learned to make my own investments, and I have always felt safe, important, and independent.

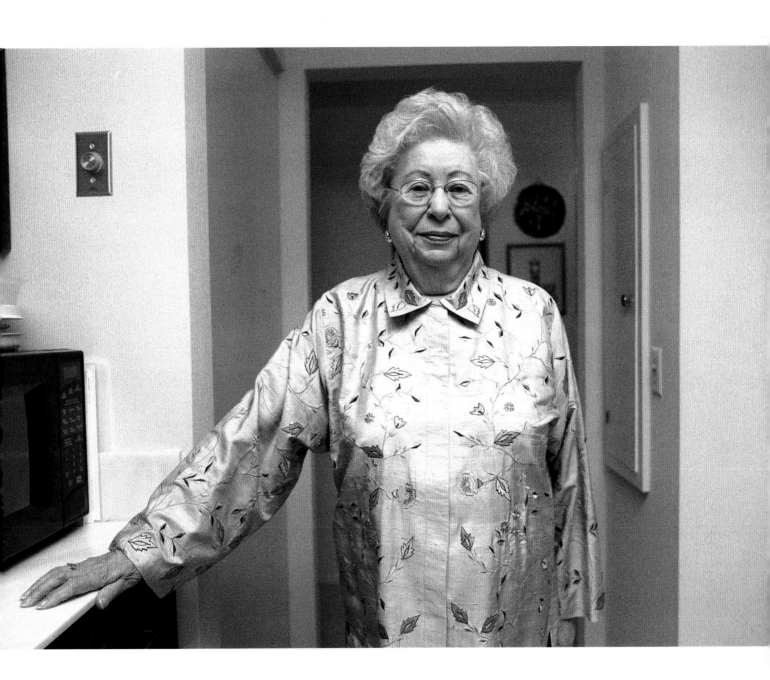

...bus
...of Soup
...cream soup, 1 Can split
...
...to + 1 soup can milk
...with rice soup, 1 Can tomato
...water + 1/2 can milk
...oup, 1 Can chicken gumbo
...water + 1/2 can milk
...oup, 1 Can split pea ...
...can water + 1/2 can milk

Serves 6 to 8

...as    ing water. Cover and steam 10 minutes.
...t least 12 leaves as they
...ave off thickest part of
...place in an 8-qt. heavy pot.
...e sauce ingredients; taste
...flavor. Set aside.
...e onion, beef, rice, egg,
...mbs, and seasoning in a
...abbage leaves out flat; about
...tom of leaf, place about 3 T
...g mixture. Fold bottom of
...fold in sides, and loosely
...e filling is covered;
...maining cabbage and use to
...tom of the pot to cushion
...rolls. Place cabbage rolls
...side down and pour the
...p. Add enough water to
...ge rolls. Bring to a slow
...er, and cook about 2 hours.
...ionally and add water if
...necessary. Best made one or two days
ahead and reheated. Serves 8-10.

...juice and
...ng uniformly to
...rgs back when

cab-
...age,
...oil.

I am still collecting recipes.
It is a part of who I am.

I like to create and eat food,
but the best part of cooking
is sharing.

This is true
for most things in life.

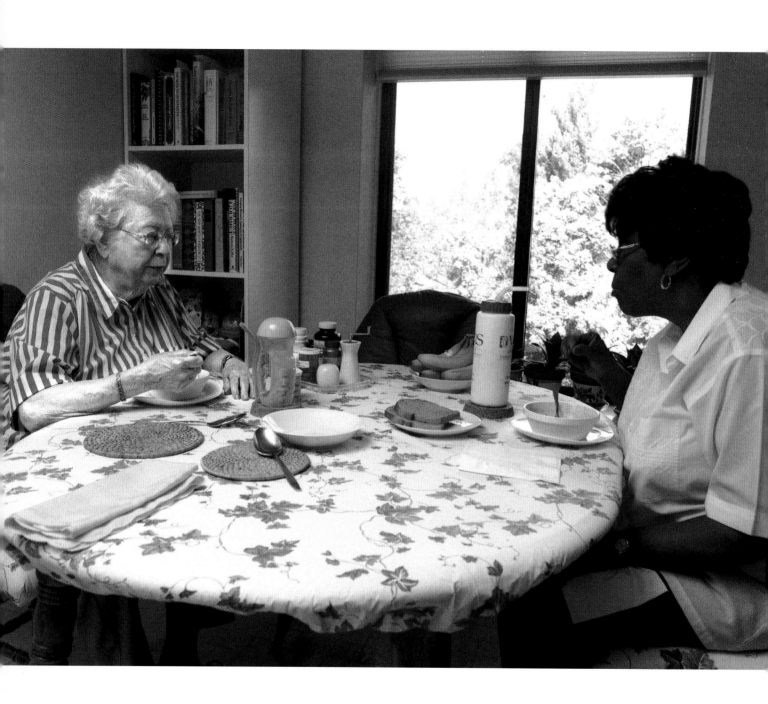

Aunt Ruth has been a widow for 11 years.  I asked her about being alone.

*I don't like it, but I have no choice. I tell myself to be strong. I keep busy, stay interested in life and socialize. I learned that I had to make my friends who were younger than I. It is very important to know the difference between people you can rely on from those you can't. I care about people. I fill my freezer with prepared foods to take to people in my building who just might want company.*

I love my family, and I love people. This is the way I think, and the way I live to keep from becoming a me-me-me person.

On Jewish holidays, nieces, nephews, cousins, and
friends call Aunt Ruth to extend their good wishes.
She ends every conversation with the same advice.

# Make sure you always have love in your life.

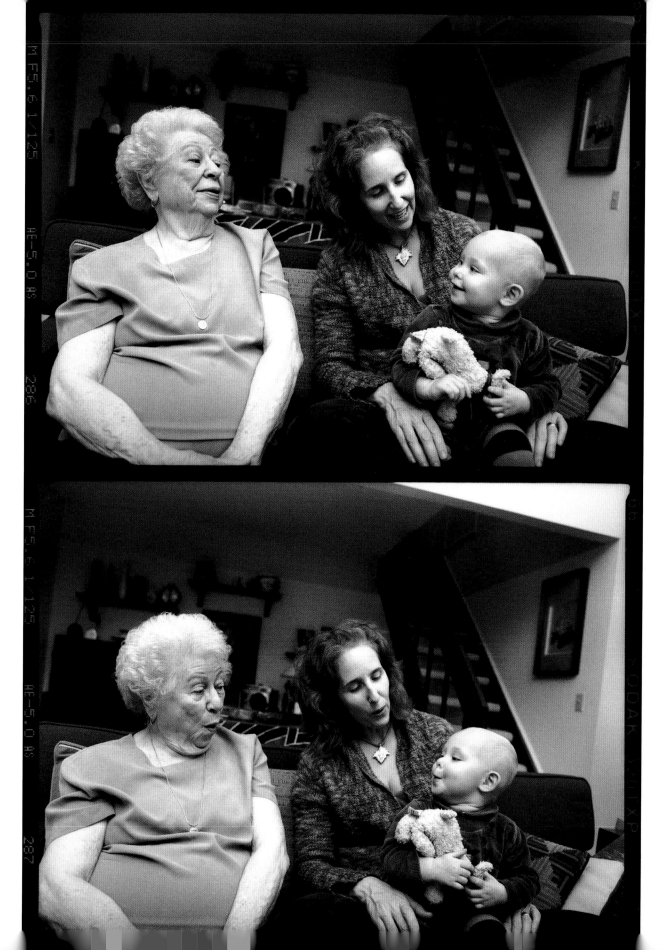

Aunt Ruth was born at home. The hospitals were full because of a flu epidemic. The house was too small for a family of five, so they moved. My grandfather converted the house into a duplex during the Depression. Aunt Ruth had a happy childood surrounded by lots of friends who remain dear to her.

There were no Jewish families in her neighborhood, so my grandmother made Christmas cookies that her children delivered.

Children don't know about race, religion, or things like that...I would see other kids and go play with them. I still feel this way about people, and I can't imagine any other way to live.

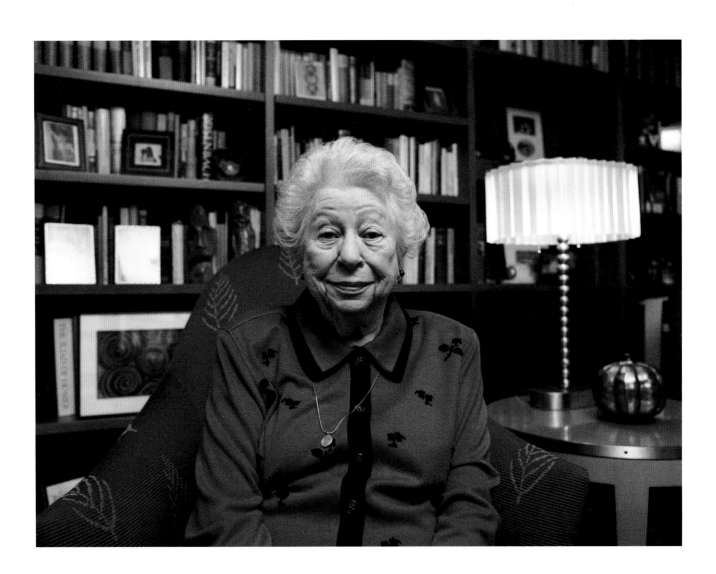

*I could have done many things differently. Little things. I spent too much of the healthy part of my life working on causes which was a family tradition learned from my own grandparents. Their apartment had floor-to-ceiling shelves filled with donation boxes for various charities. Charity came first to them. My mother told me that by the time she had grown up, she decided that her family would come first. I should have listened to my mother. The truth is that my mother figured out how to do both at once, but I never did.*

# Balancing charity or any activity with family life is the key to happiness.

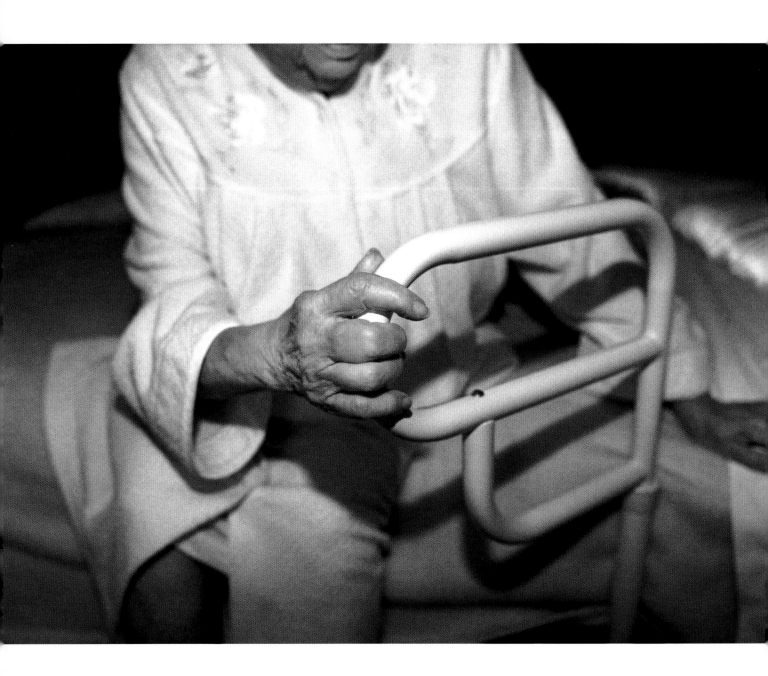

Look into the future
and imagine your needs.

As you grow older,
you will need more care.
You will rely on others, and
you must prepare for this.

*All of my mother's life, she was preparing me to live without*
*her even though I never wanted to live without her.*
*We have to make sacrifices. It is a part of life.*

You have to live for the living.

Put aside your grief to enjoy celebrations like weddings or birthdays, because they won't come again.

Sorrow will wait for you.

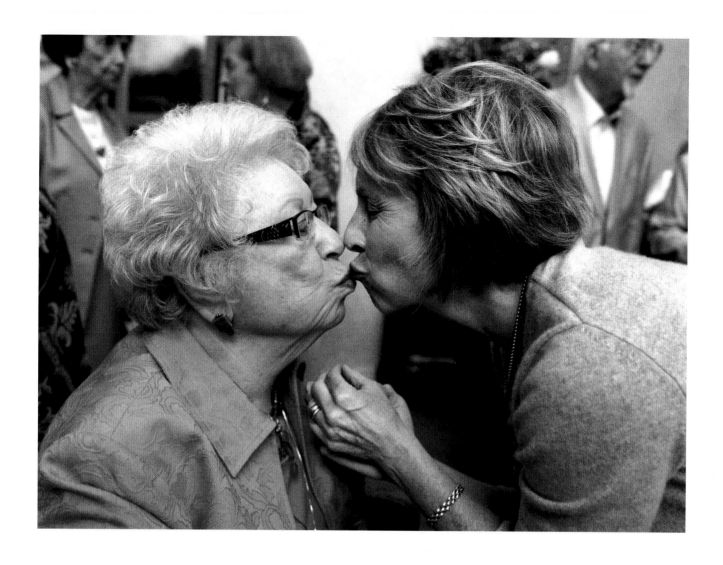

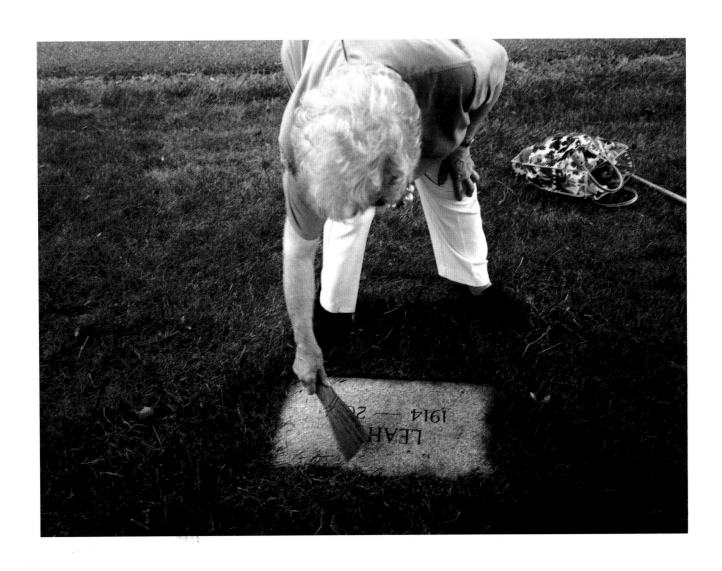

You must plan for your death the way you plan for life. Death is a part of living.

A neglected grave tells me that no one cares. I believe in honoring the lives of those who loved me, so I visit my family and make certain their graves look well-loved.

These gloves belong to Aunt Ruth, and her sister, Leah, who was my mother. The stacking represents how I see the sisters. "My sister was older than I, smarter than I, and more beautiful than I," said Aunt Ruth.

Her love was unconditional and knew no favor.

I am one of three sisters who Aunt Ruth loved equally, which occasionally caused problems for us sisters vying for attention!

See your sisters like gloves – pairs of hands that applaud each other's triumphs and hold onto one another when life is unkind.

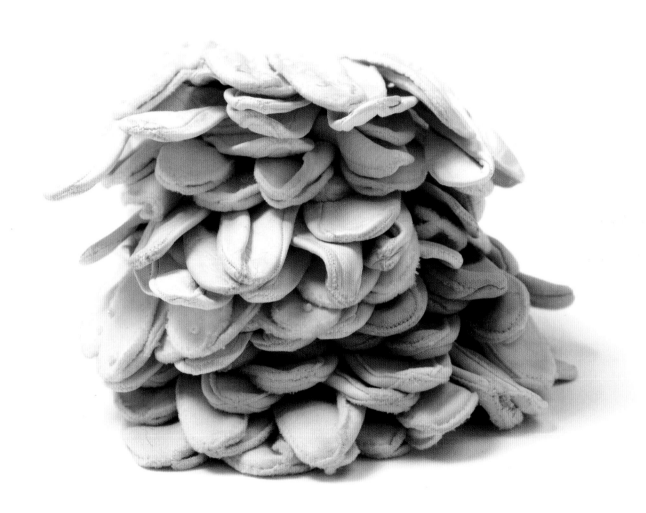

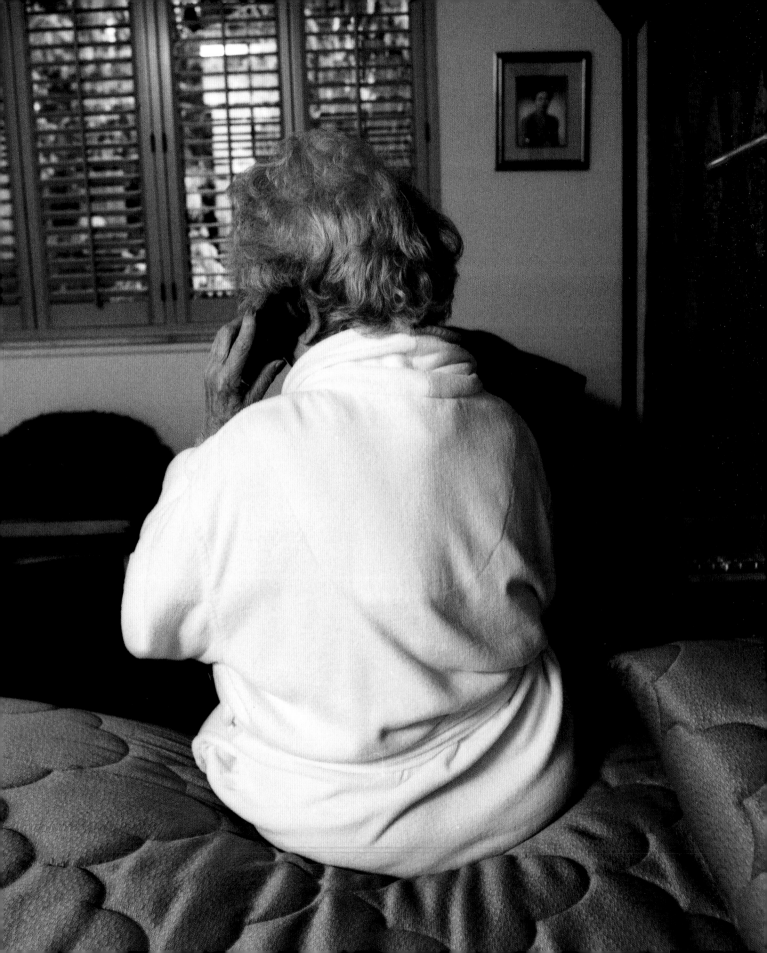

Aunt Ruth's phone never stops ringing.

In this technological age, communication is done through acronyms typed into a phone, email, or even through social networking. Although Aunt Ruth does have her own Facebook page and uses the Internet, she prefers the phone or face-to-face conversation. She is a magnet for advice because of her years of experience and her capacity for empathy. She has a legion of loyal friends of all ages, ethnicities, and economic standings. She was raised to treat everyone equally.

I strongly recommend the art of listening and practicing "live and let live" as your mantra.

This is how I have kept my friends.

I asked Aunt Ruth if I could photograph her for a book
despite not knowing if a book was possible. She said,
"Of course, I will have a tea party, so you can meet my
friends." Beautifully dressed women attended her party
from their fifties-to-nineties and talked politics as easily
as they exchanged brisket recipes. They sipped tea, ate
small sandwiches, and posed for photos only after
reapplying lipstick.

# Never stop taking care of yourself.

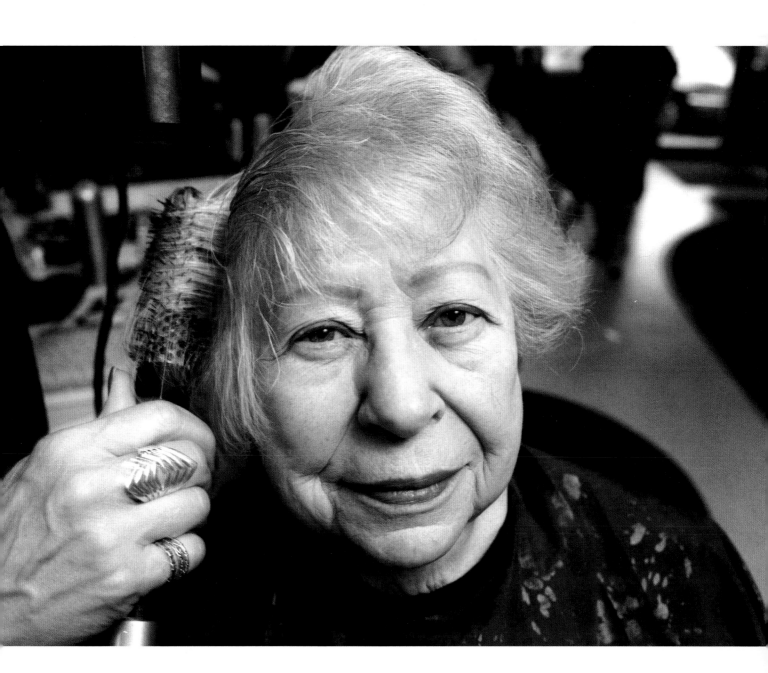

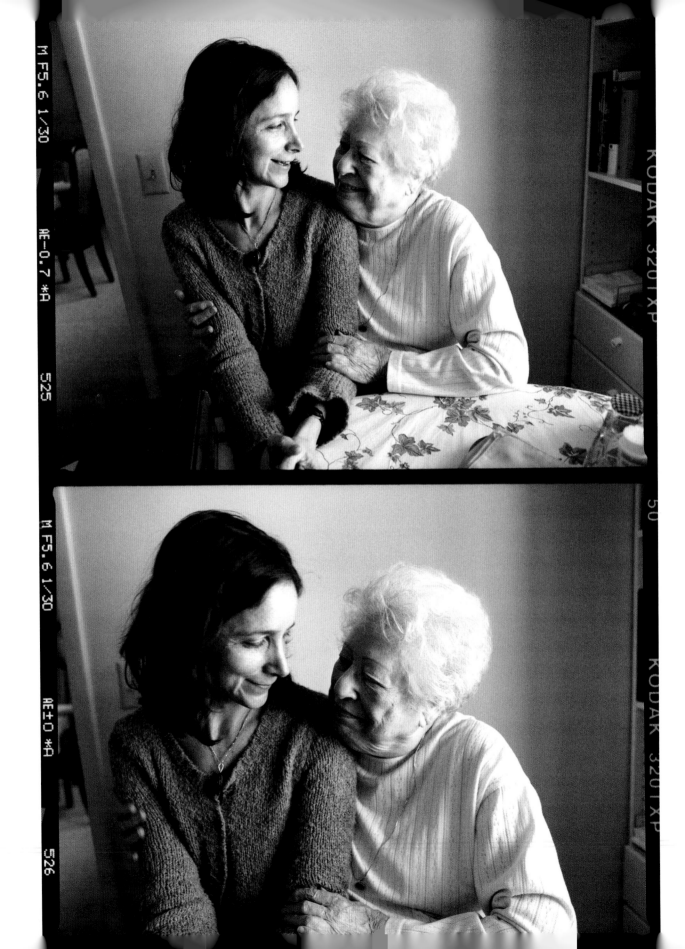

As long as you are alive,
you will have problems.
It is important to embrace joy.

If you have a homemade
cookie, you will be happy.
I like to make people happy,
so I bake cookies.
People of all ages like my
cookies, and I've been called,
"The Cookie Lady."
What is sweeter than that?

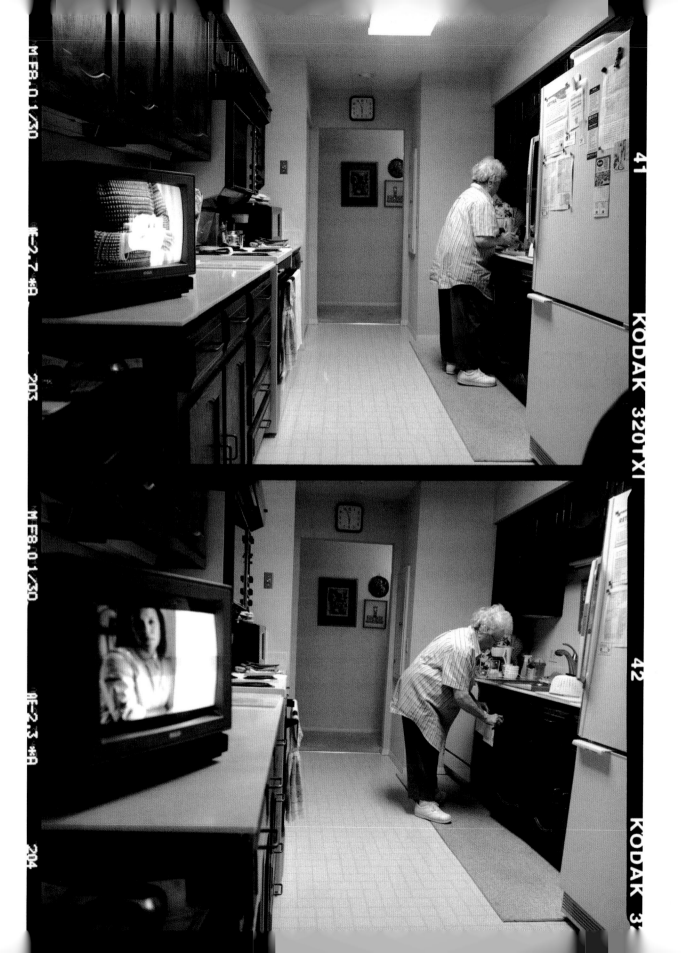

Aunt Ruth was a member of her temple for over sixty years.
She served as its President during its hundreth anniversary,
was President of the temple's Sisterhood, and worked on
every committee.  Faith and service were family traditions.

Stay connected to and be active in your community in any way that is possible. Life is far richer and more meaningful when you give to others.

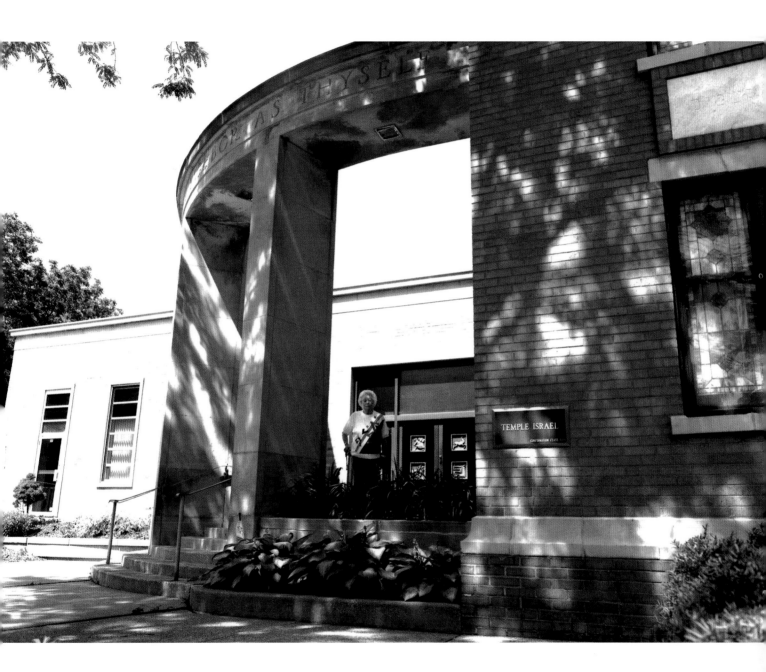

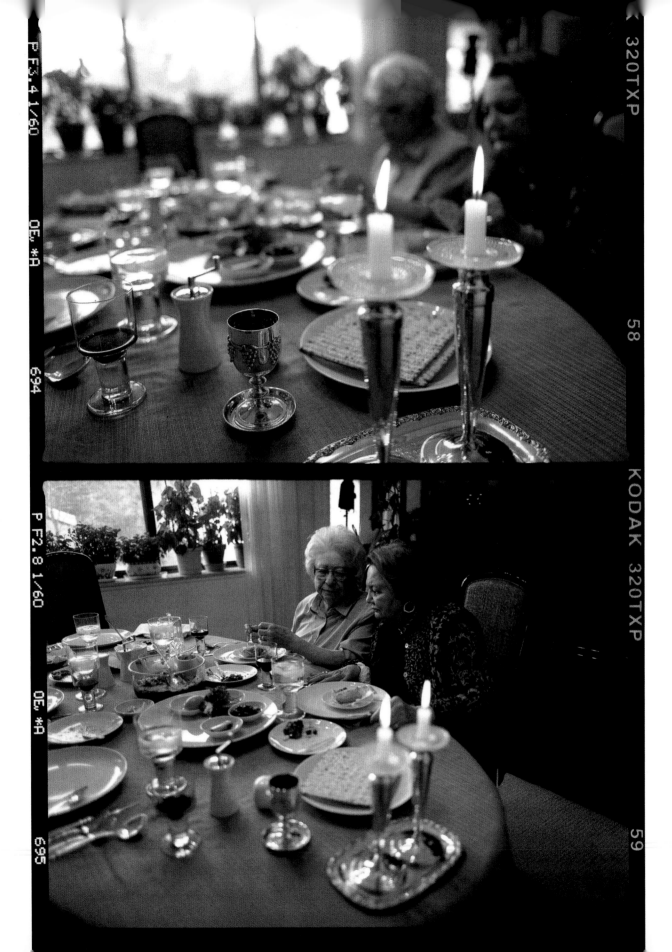

Holidays are shared with family and friends.
When Aunt Ruth was young, her ranch-style home was
filled to capacity with revelers, a habit that has not
changed despite aging and loss. Her parents led the way
with an open-door policy. Aunt Ruth said "We never knew
who was coming for dinner, and we never cared."

Celebrate everything.
Make sure your cupboards
are stocked and your freezer
is full for last-minute guests.

*I believe in God.*

*God guided me and helped me in troubled times.*
*I feel it is good to believe in many things, and I respect all*
*religions, but for me, God came first. I had great affection*
*for my mother who brought religion into our house. She was*
*an Orthodox Jew. She taught us to celebrate the Sabbath*
*and that helping the needy was a part of being Jewish.*

God has helped me to be
more understanding of
people and their problems.

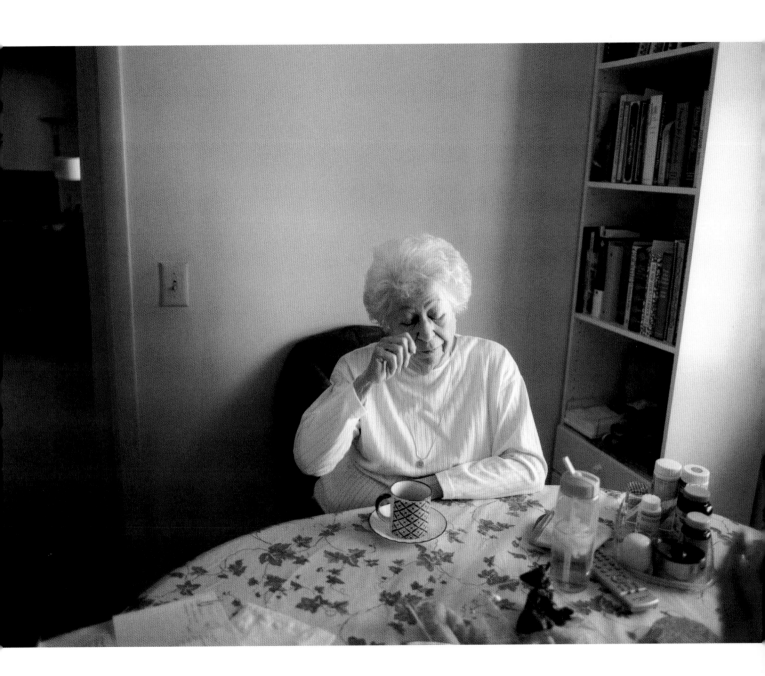

As I face aging, I see my physical changes and cringe.
I asked Aunt Ruth for advice on facing the mirror.

Sometimes, your mind makes you believe that you are young, but your body knows the truth.

I have found that my mind is far easier to keep young by reading books, the daily newspaper, attending lectures, and even learning how to use the Internet.

I stay socially active to stimulate conversation and to have a chance to listen.

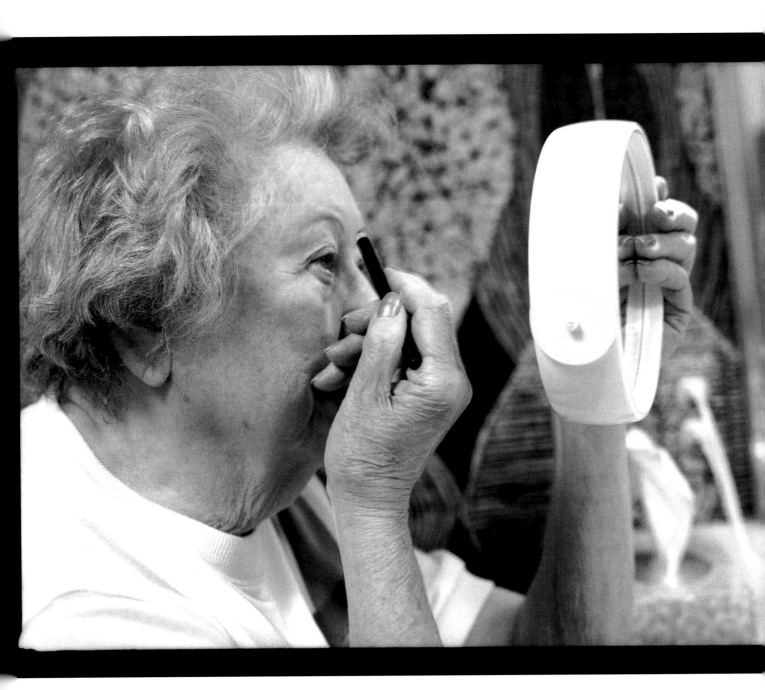

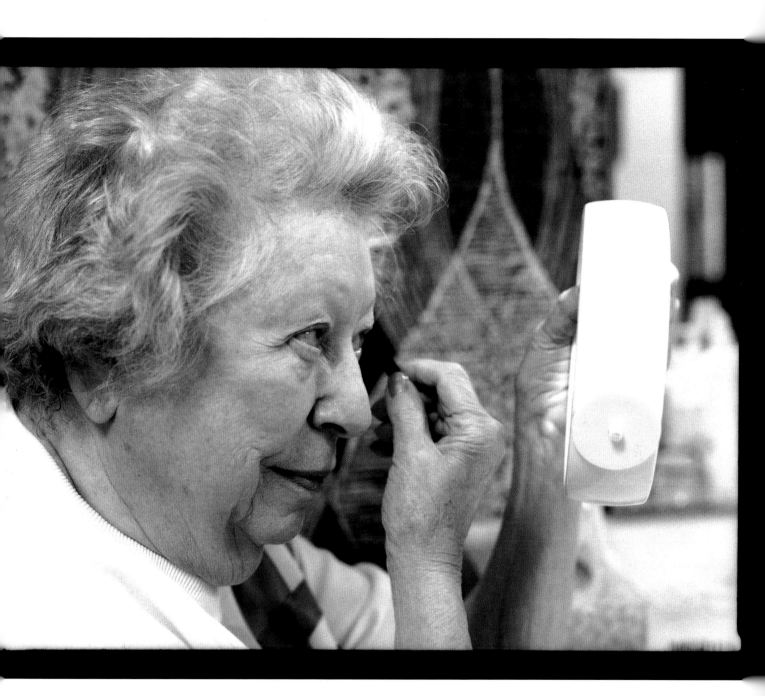

Aunt Ruth told me that a health care professional suggested that she start winding down and let herself be a passenger in this journey with someone else being the driver.

I think you should drive until your eyesight fails. I drove and repaired army staff cars during the war, and while I may be driving a walker and using a state I.D. rather than an official license, I still control the steering wheel.

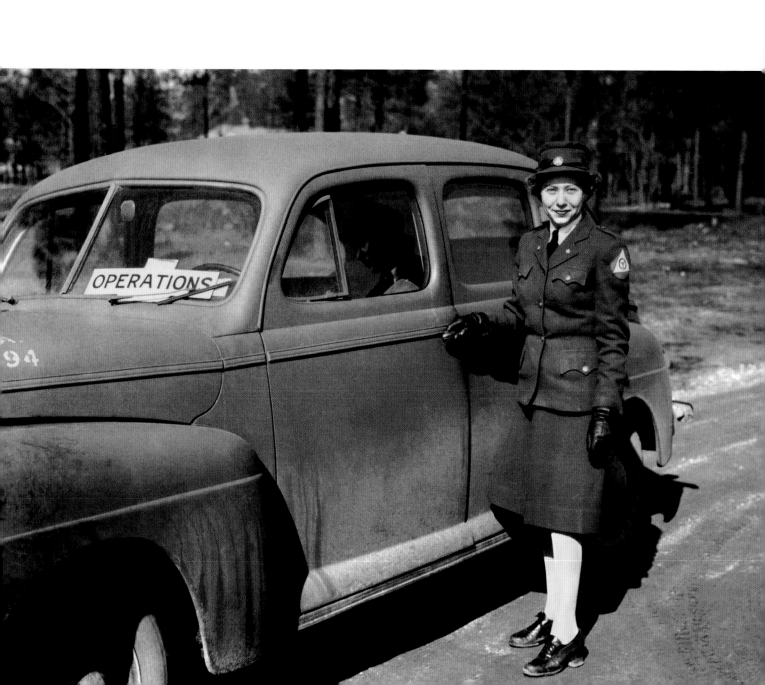

The way I started in life
I love all kinds of people,

is the way I am ending.
and I think they love me.

When you are in love, you can't think about anyone or anything else.

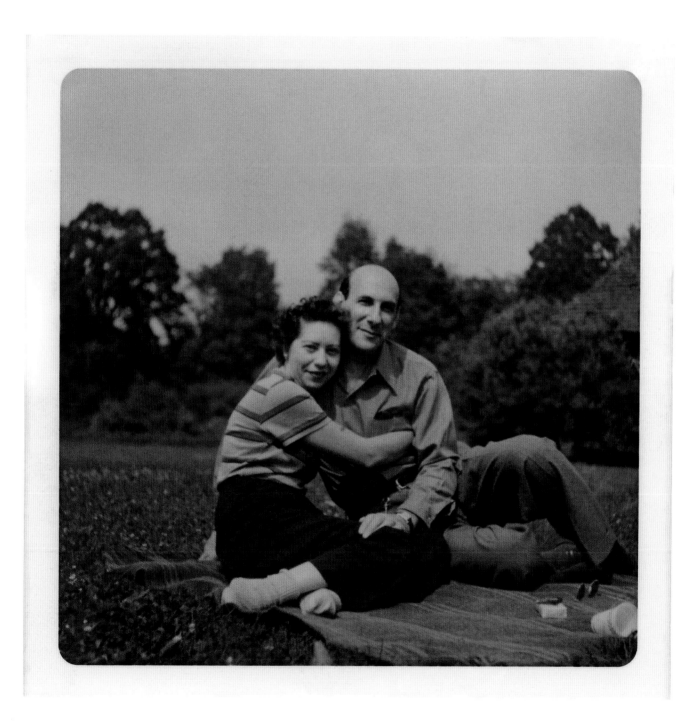

I don't understand the idea
of closure when it comes to
mourning.

I believe that you grieve with
the same depth as you loved.
I don't think you are
supposed to get over love;
I believe you move forward
surrounded by memories.

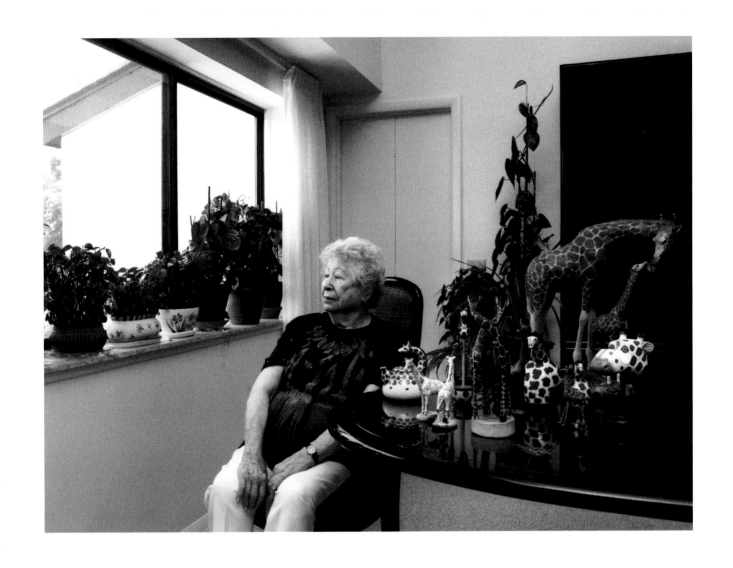

Remembering gets me into
the kitchen to cook and helps
me sleep through the night.

Aunt Ruth was married for over 60 years to my Uncle Bob.
They adopted two children, and both were gone long before my Uncle Bob
died. I wondered what she thought were the ingredients for keeping a
marriage solid.

*I grew up in a house that had a big dining room table. Our house was a duplex, so you know that the table wasn't huge, but as a child, I thought it was enormous. There were always guests at our table invited and otherwise...family, friends, neighbors. Meals were delicious and noisy fun. My mother was a great cook.*

*My husband didn't come from a family like mine. His siblings and he began working when they were twelve. When he met my family, he noticed something he found startling. My siblings and I always kissed our parents whenever we left the house, and Bob was stunned. I think he fell in love with all of us.*

*When I got married, I made sure our dinner table was as large as the room could handle. Bob was proud of our meals, our laughter, and our kisses. It may sound silly, but our happiest memories include that table, because love gathered around it.*

Being a good wife means being truthful, understanding, and loving. Marriage is not easy, but I know that without honesty and the capacity to forgive, love dissolves.
Love is the most important thing in my life.

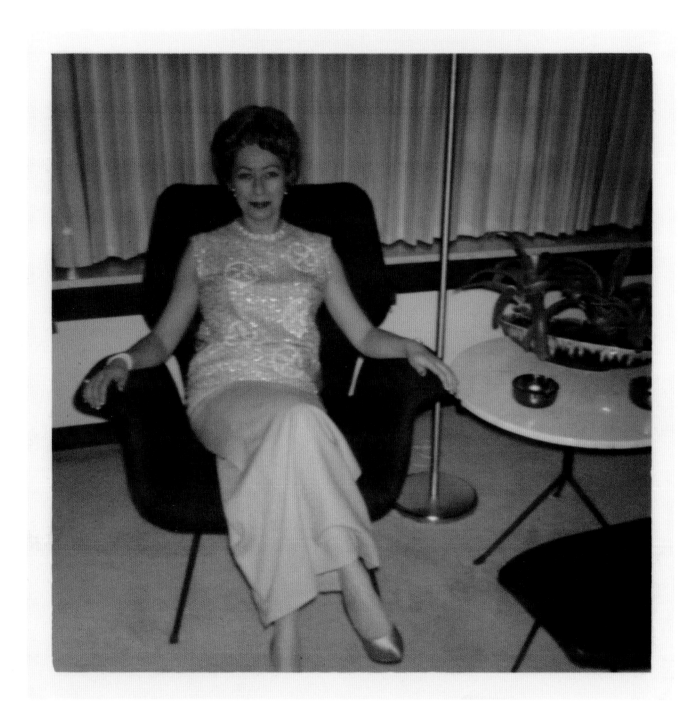

*I was driving in my car when President Roosevelt said that we were at war. The Japanese had bombed Pearl Harbor, and my life completely changed. You can't get those memories out of your mind. World War II was an 'all out war', which means that allies joined together against evil. Since then, I have lived through many wars-Vietnam, Korea, and now Afghanistan and Iraq. These are not 'all out' wars, and I don't understand them.*

I hope for a time when there is no war of any kind. I believe we must work for peace.

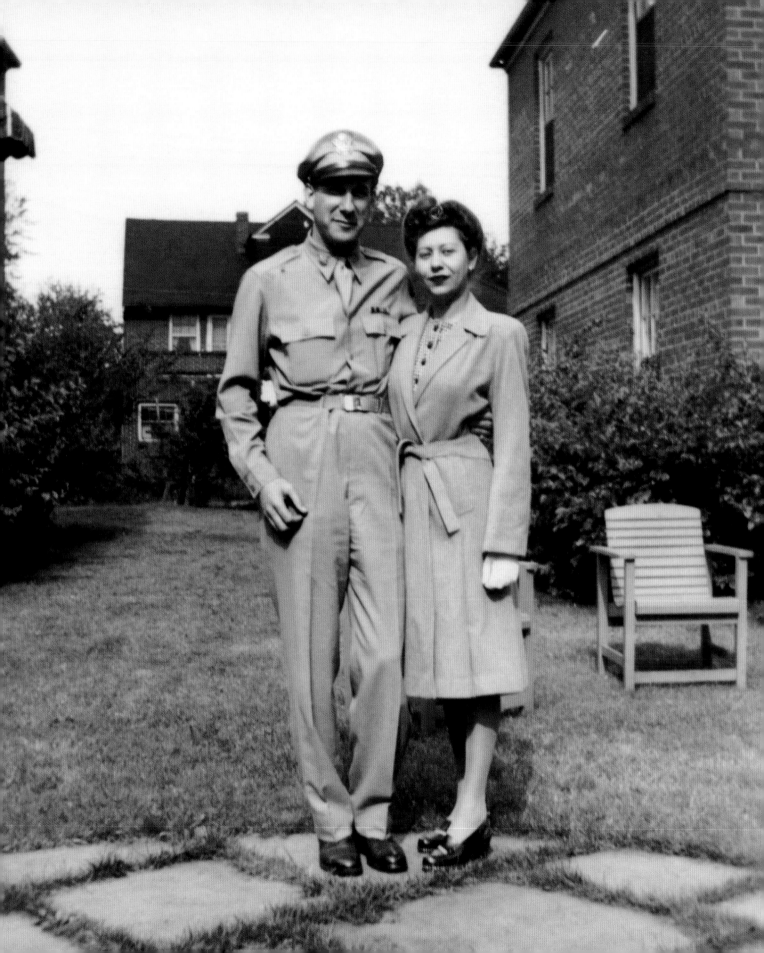

I think it is a good idea to keep pictures of family and friends close at hand, so you are reminded of how lucky you are.

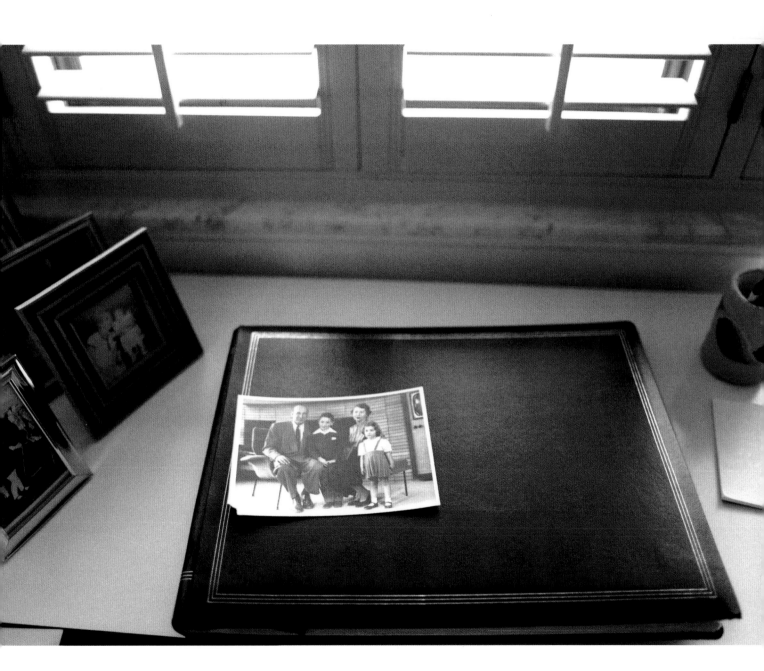

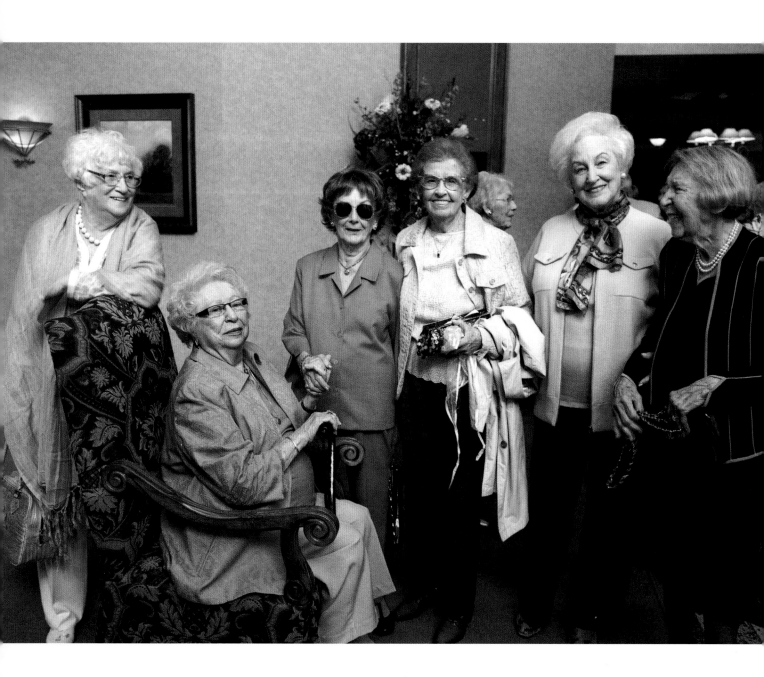

I asked Aunt Ruth how she wanted to be remembered, and she replied, "I would like to be remembered for being a nice person." One hundred and sixty-five people attended Aunt Ruth's ninetieth birthday party. Life-long friends who shared Sabbath dinners, weddings, tea parties, and shivas, all came to raise their glasses to the past and toast the future. The community that Aunt Ruth loved and inspired was diverse and devoted.

Every birthday is important.

I believe you should share them with as many people as you can afford to feed.

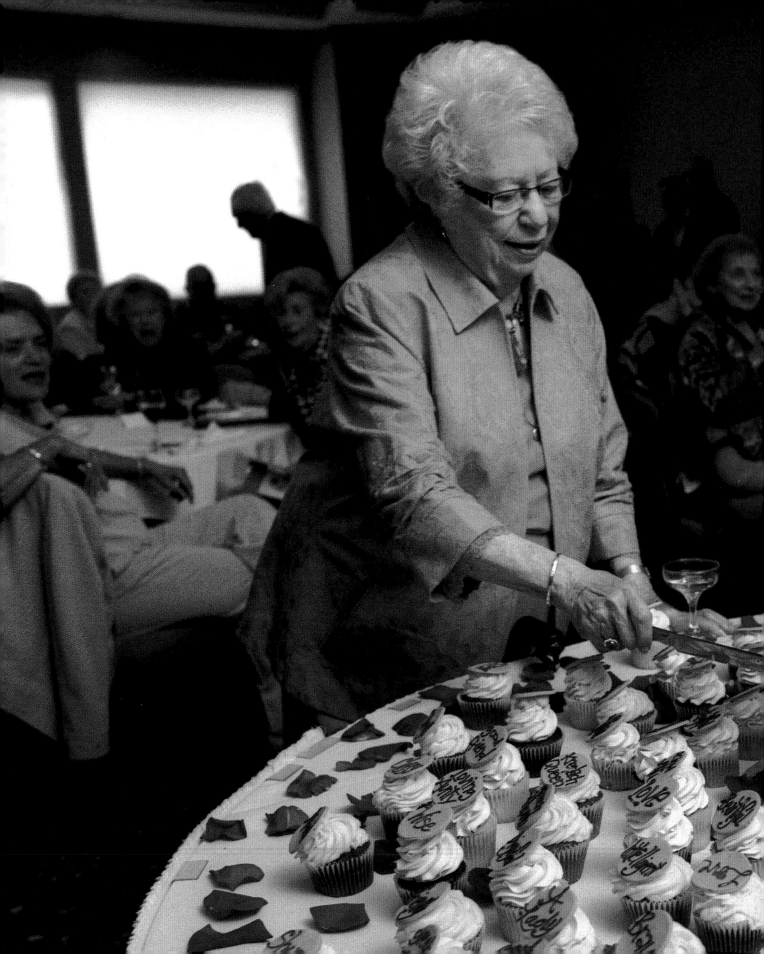

Aunt Ruth and I shared the loss of both of my sisters, her adored nieces. Although we comforted each other, our sorrow was different. No one owns grief. We talked about dying to help each other cope.

*I am not afraid to die. Of course, I would like to live, but I am not afraid. Everyone dies.*

*My mother was 73 when she knew she was going to die.*
*She called my sister, brother, and me into her room and made us promise to stick together and love each other. We did, but not because she ordered it, but because we adored one another from the beginning. We grew up in love, so she needn't have worried.*

Love has motivated everything
I have done in my life.
It is the greatest gift of all.

# AFTERWORD

Sometimes in the hazy moments of first waking, I feel especially aware of the strangeness of our world, and a bit mournful about the one we left behind. The speed and velocity of social change makes life confusing - almost unrecognizable. Indeed, too often our celebrity-obsessed, 600-gigs-per-second culture seems far more fit for cyborgs than humans. This begins to explain why I love Honey Lazar's Aunt Ruth. I met her through Honey's photographs and words, and yes - social media brought them into my life. Ahh, irony. The project ignited the memory of the kind of calm, dignified and decent living I saw more of in the world of my childhood than is celebrated today.

Through Aunt Ruth's words, and the testimony of her friends and relatives, she demonstrates a gemlike clarity of purpose. Be decent, she shows us. Be loving. Honey reiterates those values through her black and white photographs, pristine and understated. Here, we experience living well through the quiet tending of a grave, in a freshly baked cookie, and in an insistence on keeping clear the threshold to the heart.

These things sound old-fashioned and simple. As we learn, simple is harder than it looks. As for old-fashioned... I think not. Aunt Ruth's is the ultimate recipe not merely for surviving the modern world, but for thriving in it. Kindness, generosity, open-heartedness: these are the keys to staying human as we face the future.

Karen Sandstrom

Karen Sandstrom is a writer, editor and illustrator in Cleveland, Ohio. At the *Plain Dealer*, Ohio's largest newspaper, she was an award-winning book review editor for five years. Her journalism has also appeared in the *Boston Globe*, *Pittsburgh Post-Gazette*, *Columbus Dispatch* and *Art & Antiques Magazine*. She is also the illustrator of two poetry books for children by author Sara Holbrook: *Zombies! Evacuate the School!* and *Weird? Me Too! Let's Be Friends* were published in 2010 by Boyds Mills Press, an imprint of Highlights for Children.

In 1959, Temple Israel's Sisterhood published its first cookbook. Aunt Ruth, a Sisterhood President, was one of the cookbook editors. The book was revised in 1963 and 1977. Aunt Ruth tested and rated the recipes with each printing. These recipes are a selection from the "excellent" ones.

Random Thoughts By The Editor

In your quest for gracious serving don't overlook eye appeal

Have your menu well balanced as to food and color

Plates or platters should be colorful and have a plentiful garnished look

Show off your linens and dishes to the fullest advantage-stick with your color scheme

For ease in entertaining, the possibilities of your home should be taken into consideration

In the preparation of foods do feel free to adjust seasoning to suit your own tastes

Last, but not least, read the recipe through and understand it thoroughly

*Temple Israel Cook Book*, 1963

# THE RECIPES

# Hot Chicken Salad

2 C diced cooked chicken (use more)

2 t lemon juice

2 t chopped onion

2 C slivered celery

1 t Lawry's salt

1 C mayo

1/2 C slivered almonds

Combine in baking dish - cover with 1/2 C grated chedder cheese + 1 C crushed potato chips.

Bake @ 450 for 15 minutes.

One of my sister's best recipes

# Glazed Corned Beef

4 lbs cooked corned beef

1 C ketchup

1 T brown sugar

1/2 t celery seed

1 T dry mustard

2 T worcestershire sauce

2 T water

Dash of cayenne

Shortly before cooking, put meat in shallow baking pan, fat side up.

Mix rest of ingredients and pour sauce over meat.

Bake at 350 for 30 minutes.

Must try sliced on fresh rye bread with mustard

# My Meat Loaf

1 1/2 lbs ground beef

2/3 C dry bread crumbs

1 C tomato juice

2 eggs

1/4 C browned onions

1 t salt

1/4 t pepper

Topping:

3 t brown sugar

1/4 t nutmeg

1/4 C ketchup

1 t dry mustard

Gently mix first 3 ingredients until tomato juice is absorbed. In blender, put eggs and onions. Add to meat with remaining seasonings. Bake for 1 hour to 1 1/2 hours at 350. Mix topping ingredients and spread on meat.
Return to oven, and bake 30 more minutes.

I have tried a lot of meat loaf recipes. I think this one is the best

# Fillet of Sole

4 T butter

3 shallots, minced

2 t parsley, minced

2/3 C fresh mushrooms, finely chopped

2 lb fillet of sole (or flounder)

fine white breadcrumbs

2 T dry Vermouth

Liberally butter a large, shallow baking dish and sprinkle with shallots, parsley, and mushrooms. Dip sole in melted butter, dust with salt and pepper, and roll in breadcrumbs (seasoned with salt and pepper).

Arrange the fillets in the pan and top with same quantities of shallots and parsley used to line the dish. Sprinkle evenly with Vermouth, dot with butter, and bake at 450 for 12 mins.

I love taking this to my neighbors during Lent

# Spinach Kugel

8 oz wide noodles

2 boxes chopped spinach (thaw + drain)

3 well beaten eggs

6 T melted butter

1/2 or whole package of onion soup mix

1 C heavy cream

Butter a 9X9 pan.

Bake at 350 for 1 hour.

A guaranteed crowd pleaser

# Cabbage Noodles

1 lb broad egg noodles

2 large onions, sliced

1 medium head of cabbage, shredded or grated

1 stick margarine or butter

Seasoning as desired (salt, pepper, dill, sometimes garlic powder or a crushed garlic clove)

Cook noodles. Drain, rinse, and set aside.

Saute onions in fat until soft and slightly browned. Add cabbage, stir and continue to fry until onions and cabbage are medium brown.

Add sauted cabbage mixture to cooked noodles, then season to taste.

My husband's favorite

# Rene Levy's Cheesecake

Crust:

12-15 graham crackers

3/4 stick butter

18 oz cream cheese

4 eggs

2/3 C sugar

rind of 1/2 lemon

1/2 t vanilla extract

Topping:

1 pint sour cream

1/3 C sugar

Crush graham crackers with butter and line bottom of a springform pan. Cream
cheese, add sugar, then eggs, and cream again. Add lemon rind and vanilla.
Bake in a springform pan at 375 for 30 minutes.
Mix topping ingredients, spoon over top of cheese batter, and bake for 8 minutes.

I like to top mine with chopped nuts

# Apple Cake

2 C flour

3 t baking powder

1/2 C sugar

3/4 C butter

2 eggs

1 t vanilla

Topping:

8/10 apples

1/4 C butter

1/2 C sugar

cinnamon

Crumble first 4 ingredients together until grainy. Add 2 eggs and vanilla.
Mix until it forms a ball. Pat into greased jelly roll pan. Peel + cut 8-10 apples
and arrange on top. Mix 1/4 C (melted) butter, 1/2 C sugar + pour over apples.
Sprinkle with cinnamon. Bake @ 375 for 40 minutes.

This is my cousin, Hilda's favorite cake

*I love you for ever and ever.*

Ruth Moss 1919-2013

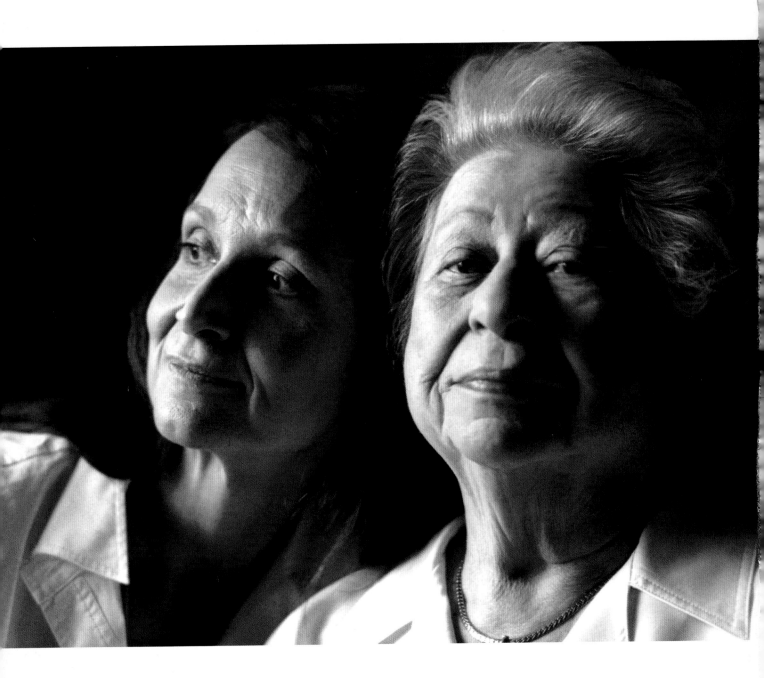